HOW TO RECOGNIZE

GREEK

ART

PENGUIN BOOKS

Author Dr Flavio Conti
Idea and realization Harry C. Lindinger
Graphic design Gerry Valsecchi
Artist Mariarosa Conti
Translators Erica and Arthur Propper

Contents

Penguin Books, 625 Madison Avenue, New York, New York 10022
Penguin Books Canada Limited, 2801 John Street, Markham, Ontario, Canada L3R 1B4

First published in Italy by Rizzoli Editore, Milan, 1978
First published in Great Britain by Macdonald Educational Ltd 1978
First published in the United States of America and Canada by Penguin Books 1979

Printed in Italy by Rizzoli Editore

Introduction

This book deals with the art of Greece and other Greek-speaking countries between the eighth and fourth centuries BC. It does not cover Mycenaean art, which preceded it, or the art of the succeeding Hellenistic period. Though both shared many points of contact with the art of the period described in this book their quite different philosophical and political bases led them to produce works greatly dissimilar to those of the five centuries up to about the year 400 BC.

Though the time-span in question is the same that separates us from the Renaissance it may seem rather limited; but the geographical area, by contrast, is remarkably wide. The Greeks, or Hellenes, as they called themselves, were not a homogeneous people but a series of tribes sharing more or less the same language, the same principal gods, and a common awareness of descent from the same ancestors. By race, or rather by language, they were Indo-Europeans, kinsmen of the Latins, the Teutons, the ancient Persians, and the Hindus.

With the first use of the horse some time around the beginning of the second millennium BC, they invaded and settled the southern end of the Balkan peninsula. In time they came to feel hemmed in and resorted to the establishment of colonies, emigrating mainly to Sicily, to the southern coasts of Italy, to the shores of Asia Minor, and to Cyrenaica. There, their transplanted civilization flourished, in some cases more precociously than the original in Greece itself. On the Italian peninsula and in Sicily especially, it came to be described as Megale Hellas or Magna Graecia: 'Great Greece' in the sense of a new world of generally superior prosperity. This relation between Greece and its colonies was one that repeated itself throughout several centuries.

The civilization of Greece and its colonies was uniform, however, in its character. It valued, above all, reason and the love of beauty, which was understood as a

▶ Greek temples tended to be rectangular in plan; but some were circular, as for example at the Delphic shrine. Delphi, renowned for its oracle, was the centre of the cult maintained by the Amphictyonic league of Greek tribes. The temple itself was a sanctuary in honour of the goddess Athena, or, to the Romans, Minerva. Its slender columns exemplify a transition from the massive proportions of the Doric order.

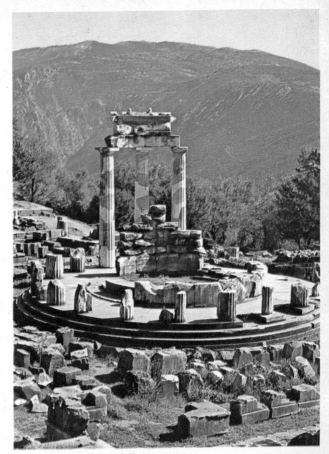

▼ Detail from a cup by the Attic potter Exekius, one of the principal painters of black figure vases. The ship, which appears frequently on Greek ceramics, is the symbol of power and of life itself.

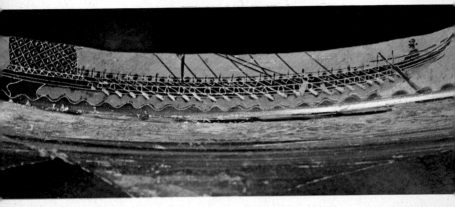

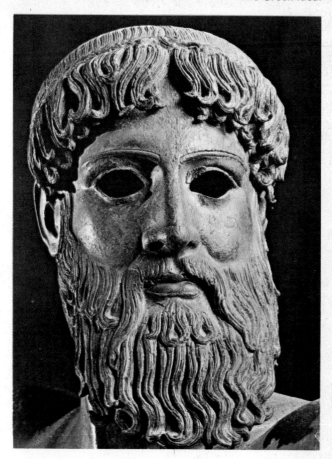

▶ *The God from the Sea*, an original bronze sculpture representing Poseidon (the Roman Neptune). It dates from the first half of the fifth century BC. Perfectly shaped and proportioned, it is a masterly expression of the Greek concept of a vigorous, mature man. Though some details, such as the stylization of the eyebrows and the geometrical regularity of the hair and beard, are still in the archaic manner, such statues were the culmination of two hundred years' experience in portraying the human body.

supreme harmony between things in the form of accordance between appearance and reality. Out of the ideas and principles of this civilization came splendid material achievements. To appreciate these – whether buildings, statues, or paintings – we need to understand the rules that gave them significance for the men who made them. The quality of aesthetic attainment that accompanied and arose from the ideals of classical Greece – that is, around the fifth century BC – is among the highest in history. Many of the artistic concepts and forms that they engendered still survive; and Western society responds even now to the impetus that Greek civilization gave to the human spirit 2,500 years ago.

Architecture

The foundations of Greek architecture were laid in the period known as the Greek Dark Ages, the formative period for the whole of Greek civilization, which began to unfold in the seventh century BC. It was a time of transition and barbarism, spanning the five centuries that followed the collapse of Mycenaean civilization in about 1100 BC.

The Greeks could have taken their inspiration for the monuments and building that they began to construct on their newly won territory from a number of sources. They could have imitated the vast castles left there by the Achaeans, or looked further back to the lavish palaces built by the rich merchants of the island of Crete. Alternatively, they could have been influenced by the superb achievements of the Asiatic civilizations: those of the Hittites, Assyrians, and Egyptians.

Instead they looked to their own genius and created a wholly original architectural world. They based their

▼ Several methods of building construction were known to the Greeks. They included the arch and the vault; but these were used only in minor or purely utilitarian buildings. In their more important ceremonial buildings the post and lintel system was used. This, the simplest of methods, consisted of a horizontal block of stone, the architrave, with two vertical supports.

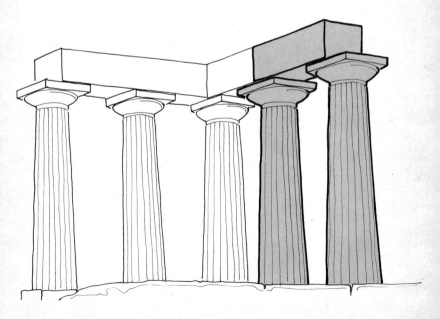

buildings on the primitive Mycenaean wooden temple and the simple concept of a *megaron*, a large colonnaded central room. This was to be the foundation for more than two thousand years of art history, throughout which the ancient Greeks were to be revered for their unsurpassable skills in architecture, painting, and sculpture.

For each of these arts the Greeks laid down rules which were analogous to the laws of nature; and nature was the standard of perfection by which they judged their art. For architecture they set up a framework of rules to which each building must comply; and in order to recognize Greek architecture and be able to distinguish it from its almost endless imitations, it is enough to know these rules, or at least understand the principles behind them.

They derived from a rigorous process of analysis and selection. A single constructive system provided the foundation of Greek architecture, which readily rejected everything lacking in practical relevance. The system chosen, the post and lintel, was not only the simplest available, but conceptually the most banal and to all appearances the most limited. This was the basic unit of construction in the dolmens, the great prehistoric tombs

▼ The temple of Apollo at Corinth. The entire superstructure has disappeared and only a few columns linked by architraves survive. The city of Corinth, in the centre of the Hellenic peninsula, gave its name to the famous isthmus and was a great commercial centre even in remote antiquity.

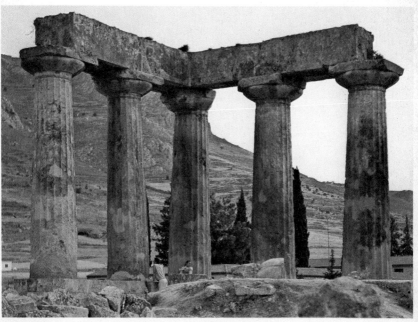

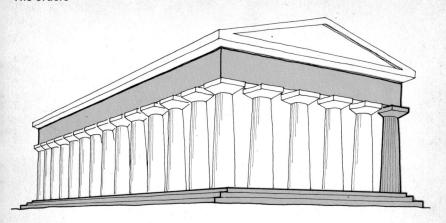

▲ As their characteristic expression of the construction system of post and lintel, the Greeks developed the idea of the 'order'. Essentially, the order set out the basic elements and their components. Each of these had its specific function and form — the column with its base and capital, the architrave with its decorated frieze, and so on. All were linked according to recognized rules of composition and proportion. Working within these rules, the architect was then free to refine and embellish as he chose.

of England, western France, and Apulia. It comprised one horizontal block of stone laid across two supports, a device that excluded any stress but the vertical; the weight of the horizontal stone rested evenly on its supports and passed directly downward.

The emergence of the post and lintel as the basic architectural form imposed a drastic limitation on the kinds of building that could be erected. The cities of the Greek-speaking world featured structures of many purposes; but the only one that resulted from any especial theory was the temple. This was standardized both in its layout and its general shape. There was a rectangular-shaped room, the cella, or *naos* in Greek, with columns all round it, which was the sanctuary of the god. The cella might have rooms both before and behind; and its columns might be variously arranged: along one side only, on two facing sides, or in two rectangular parallel rows. In a few exceptional cases, the cella, and consequently the temple, was circular. The effect of this system would have been limiting in the extreme, but for the use of an invention so outstanding that it became adopted by architects virtually into modern times.

This invention depended for its success on the fact that any building constructed on the principle of the post and lintel could be divided into certain fixed elements. These were: the base, on which the supports rested; the supports themselves – the wall and columns – which took the weight of the roof and transmitted it to the ground;

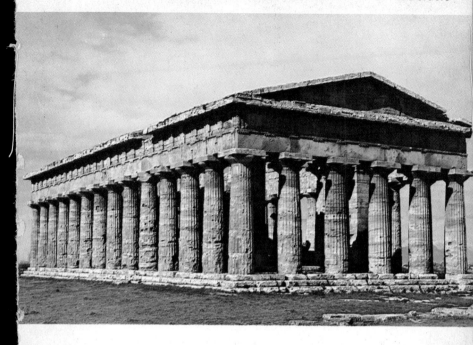

▲ Paestum, called Posidonia by the Greeks, was one of the most flourishing towns in what was known as Magna Graecia, the region of southern Italy colonized by the Hellenic tribes. Here some of the finest examples of Greek temples have survived. This is the temple of Poseidon, built according to the Doric order in the fifth century BC.

and the block of stone connecting the supports and transmitting to them its own weight and that of the roof-beams and tiles. The innovation produced by the Greeks was the combination of these elements according to pre-established general rules, subsequently known as 'orders'.

The Greeks' absence of sympathy with innovation as a norm led them, meanwhile, to believe that worthwhile results were unlikely if each new building were designed from scratch. Instead their architects worked to a system of reference that was universally available. At the centre of this system stood the concept of a standard building, and a standard technique for constructing it. This concept was expressed in a system of forms, and sometimes, too, of proportions, which related the scale of the materials – the individual blocks of stone – to that of the finished building. This mode of treatment enabled the main features of the temple to be established by simply putting together its constituent elements. There were essentially two such sets of general rules or 'orders', the Doric and Ionic, with a third, Corinthian, a later

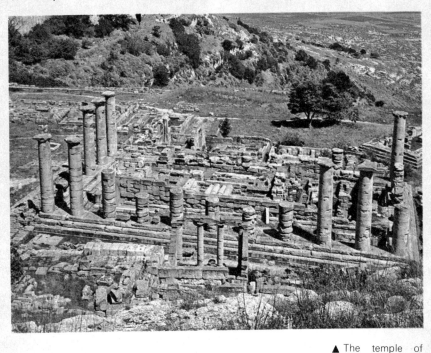

▲ The temple of Apollo at Cyrene, a Greek colony on the Libyan coast. It was perhaps unfinished, since its columns are unfluted. It is rectangular and colonnaded, in a manner common to classical examples.

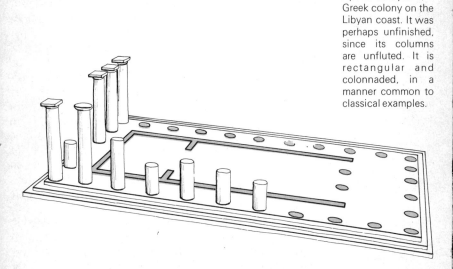

development from Ionic. The first two took their names from the main Hellenic tribes, but only loosely so. Indeed within the Doric order, the most beautiful of all temples, the Parthenon, was built in the principal Ionian city of Athens.

An understanding of Greek architecture, therefore, basically requires only a knowledge of the three orders, with their main modifications. We know little of their actual development, since this took place during the Dark Ages of Hellenic history, in the wake of the Greek invasion. Information on the architecture of this epoch is fragmentary and unreliable, as virtually none of its temples survive. By the advent of more closely recorded times the basic concepts of classical Greek art had already become established.

Of the orders, the most important to later developments was the Doric. In its definitive form, which, in the oldest of the surviving temples, can still be seen, it consisted of a foundation, the stereobate, surmounted by a range of generally three steps. The top step is known as the stylobate. In the Doric order the columns never had a base, and for this reason were placed directly on its surface. The stylobate thus connected the foundation with the support elements. The shaft, or main body, of the column was topped by a capital, which connected it with the roof. The shaft might be monolithic – that is, shaped from a single block of stone – but it usually consisted of a series of stone drums placed one on top of the other. Together with the capital it was a characteristic feature of the Doric order. Throughout Greek architecture generally, the shaft was always closely ribbed rather than smooth, with the grooves or flutings running from top to bottom. The number of grooves varied from sixteen to twenty-four, depending on the period and the individual building; during the fifth century BC, for example, they usually numbered about twenty. Seen in section from above, as in an architect's plan, the flutings had an elliptical outline coming to a point as the profile of each fluting met those on either side at an angle. The shaft itself displayed a typically Greek mastery of detail. It rose with uniform thickness to about a third of its height, and then gradually tapered towards the capital. The effect of these proportions was to produce the illusion of a bulge towards the base, and gave the column

◀ To the Greeks it was the temple that embodied their architectural ideals. The method of construction (the post and lintel) and the shape (the order) were standardized, and from generation to generation effort was concentrated on making these basic arrangements more harmonious.

This illustration shows the 'canonical' or standard form of the Greek temple. It comprised a rectangular cella, often with additional rooms along its two shorter sides, completely surrounded by columns.

The Doric order

▼ The main features of the austere Doric order include a stepped base; columns decorated with elliptical fluting; and capitals with three parts: a collar, achinus, and abacus. On these rest an architrave, and a frieze decorated alternately with incisions called triglyphs, and sculptured tablets known as metopes.

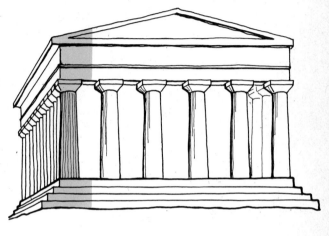

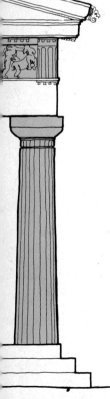

a characteristically 'potbellied' appearance, as if it were being pressed down by the weight of the roof. The Greek word for this effect was *entasis*, which means a convex curve. In the Doric order the function of a capital was undertaken by a combination of three parts: a small collar fluted like the shaft but separated from it by a small incision; the echinus, a form of bolster; and a flattened cube, the abacus.

By the use of this succession of varied elements, any abruptness was avoided in the line of the column. The collar, which had the same diameter as the shaft, in effect continued the shaft into the capital. The small square mass of the abacus made a perfectly contrived link between the circular column and the sharp angle at the edge of the roof, and in between the collar and the abacus, the gently curved echinus smoothed the transition from the narrow support surface of the column to the large area of the roof-beam.

The components of the roof were likewise graduated. Each capital was linked to the next by a smooth block of

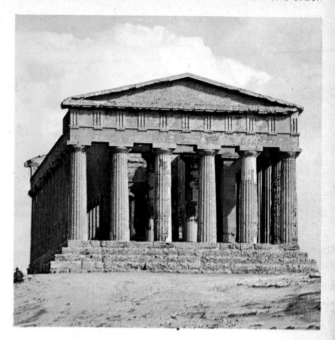

► The Concordia temple at Agrigento, one of Sicily's major towns during the period of Greek colonization. A textbook example of Doric architecture, it was built in the fifth century BC.

stone known as the architrave. On this rested the frieze, a decorative series of tablets with vertical flutings in groups of three, called triglyphs. These were separated by metopes: small, approximately square spaces, usually ornamented with sculpture. It is easy to see how triglyphs and metopes repeated on a smaller scale the pattern below them, where a space filled by a column alternated with a space left empty.

Above the frieze rested the main cornice. This served as the eaves of the building and protected the stonework below from the rain. The cornice was decorated with a series of small rectangular plates, known as mutules, of which there was one for each metope and triglyph. The mutules, in turn, were ornamented with small pegs shaped like truncated cones; these were called guttae. The roof itself was supported by the cornice and sloped so as to form a triangle, the pediment, along each of the temple's two shorter sides.

Such a description of the essentials of the Doric order is necessary in order to appreciate Greek architecture in

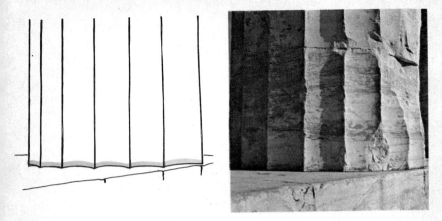

▲ One of the columns of the Parthenon. The most significant feature in the Doric column was the flutings — semi-elliptical incisions that ran the length of the shaft. Each joined its neighbours at a sharp angle, often so much so that even today the edges can be almost sharp enough to cut. The number of flutings averaged twenty, but varied from sixteen to twenty-four depending on the date and size of the building. They were cut after the temple had been constructed.

general, as most of these technical terms are common to the two other main orders. The same terms, moreover, through their application to the art of ancient Rome, the Renaissance, the Baroque, and the Neo-Classical, have become established in the architectural vocabulary of the Western world. In Greek architecture as a whole, they denote those formal elements that became its fixed components.

It was the actual form of these elements, meanwhile, that provided scope for experiment by individual architects. Between the 'archaic' period of the seventh and sixth centuries and the 'classical' era of Pericles and Phidias in the fifth century BC, these basic elements gradually underwent various changes. The *entasis*, originally so pronounced, by stages became attenuated, though it never disappeared completely. The echinus, which in archaic temples like the basilica of Paestum had such ample curves and such a flattened shape, developed a far more pronounced profile, becoming, as on the Parthenon, virtually conical. The columns, which at first were squat, became progressively more slender and tapering. A comparison of these two temples would show that the height of the columns was respectively four and five-and-a-half times the diameter of their base. On the other hand, the height of the entablature – that is, the architrave, frieze, and cornice – had diminished by the time of the Parthenon's construction, from one-half the height of the columns, to one-third – a change that was in

► A single Doric column, all that remains of the temple at Lacinia near Crotone in southern Italy. In its typical form the Doric column tapered from about a third of the way up, making it appear slightly convex. This gave the temples that featured this order an incomparable appearance of weight uplifted, an effect most pronounced in the columns of the oldest temples.

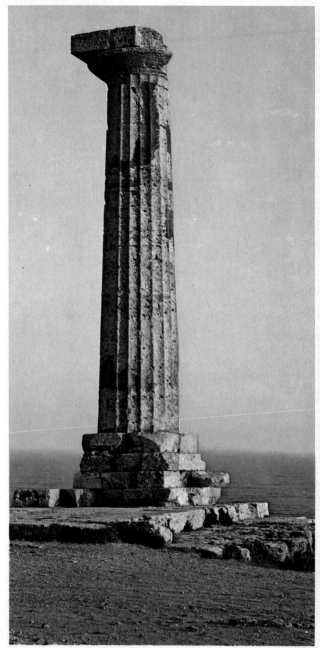

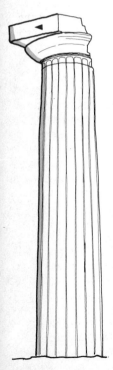

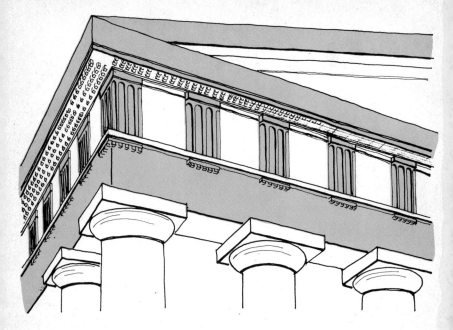

▲ The decoration along the upper part of the Doric temple was, together with the column, its most readily recognizable feature. Triglyphs and metopes alternated rhythmically, echoing on a smaller scale the spacing of the columns. The space between columns corresponded to two metopes and three triglyphs. This inevitably caused difficulties at the corners of the building, where the triglyphs should, but did not, coincide with the axis of the column below it.

some examples much greater. These discrepancies are a reliable means of establishing the relative age of a building: for example, the more pronounced the *entasis*, the older the whole structure.

There was nothing inflexible about the rules embodied in the Greek orders. They expressed archetypes or abstract principles whose forms were continually changed and improved upon as they came to be realized in actual buildings – very much as human beings are each unique within a common species.

Human characteristics in fact came to be attributed to different orders, by critics of the Romantic period, who found an association of Doric with the masculine character and Ionic, which developed at about the same time, with the feminine, being graceful but also less practical. Mainly these orders differed in the treatment of the column and especially the capital. In the Ionic form this component was much more complex, with its appearance at front and back differing from that of the sides. Seen from the front of the building, where they

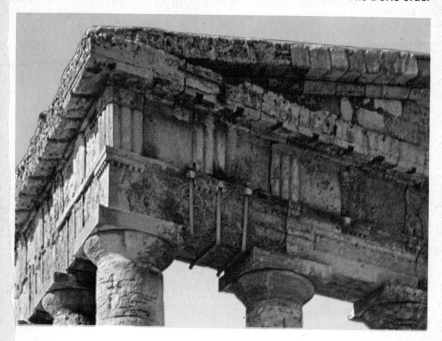

▲ The temple at Segesta in Sicily, built towards the end of the fifth century BC. It was probably left unfinished, since the columns are un-fluted and the pedi-ments are unsculp-ted.

were conspicuous among the other elements, the capitals each displayed two volutes, or spirals, linked by the lines of a curve, very like a roll of paper stretched in the middle with its ends curled towards each other. The outer sides of the roll, meanwhile, were smooth in appearance. Each capital was supported by a gracefully decorated collar.

While, however, the overall effect was certainly elegant, the Ionic capitals were structurally much less practical than the Doric. This was especially so in the temples of the classical period known as peripteral – that is, those with a row of columns on all four sides. On such buildings the difference between the front and side views of the capitals meant that at each corner of the temple, one column was bound to appear different from the others. To cope with this the Greeks devised a con-junction of two capitals to form one asymmetrical whole (see pp. 19 and 21). As a solution to the problem it was ingenious, but nonetheless clearly a makeshift. An adequate improvement on it was not found until very much later, during the Hellenistic period, when the device

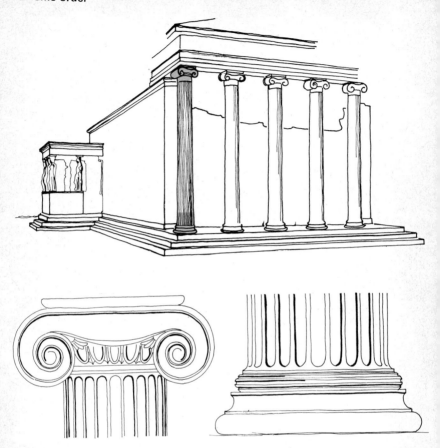

▲ The graceful Ionic order has been described by some critics as 'feminine'. Ionic capitals had volutes shaped like a scroll, and the columns had an identifiable base.

was adopted of making the capital symmetrical by attaching a pair of volutes to each side. Another difference between the two orders was the base, which in Ionic columns was an essential component. In contrast to the Doric order it provided an intermediate element between the shaft and the stylobate. It was made up of a series of mouldings in the form of stone discs of varying outlines, which rested in turn on the plinth, a pedestal resembling the Doric abacus. The plinth was not however indispensable to the Ionic order; in Athenian examples, for instance, the columns simply ended with a base.

There were also differences between the orders in the treatment of the shaft. In the Ionic order its proportions

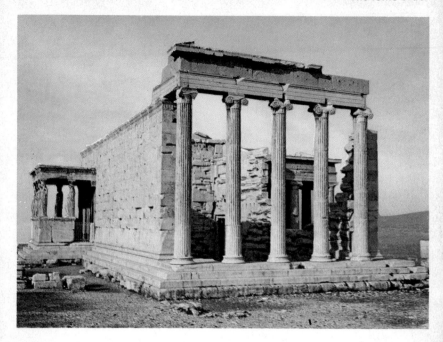

▲ The Erechtheum of Athens. This is one of the supreme works of the Ionic order and almost contemporary with the Parthenon, the masterpiece of the Doric. The asymmetrical plan is unique, and has led to suggestions that the building was never completed.

were more slender and it was sometimes sculpted from a single block of stone. The flutings were deeper than in the Doric order; they were semicircular instead of elliptical; and, above all, they were not continuous when seen in section but separated from each other by a fillet, or narrow smooth band. Immediately above the columns, the architrave was made up of three horizontals, or fasciae, each projecting slightly beyond the one below, in contrast to the single smooth block of the Doric architrave. The frieze, in the Ionic, surrounded the temple and was sometimes sculpted.

Lastly, Ionic columns differed from Doric in dimension and overall proportion. Seen from in front they were more slender; their *entasis*, or apparent convex curve, was much less pronounced; and they were sometimes placed at a greater distance from each other. In general, buildings of the Ionic order had the dimensions appropriate to a wooden structure – understandably so, since their form may well have been derived from wooden prototypes. There are uncertainties however about this.

On the one hand, both the individual elements of Ionic buildings and their general appearance seem so well adapted to the use of stone that it is difficult to envisage the use of any other material. On the other hand, many details are almost inexplicable except on the assumption that they derived from wooden buildings. There appear, for example, to be structural traces of the bolts securing the beams, in the form of the mutules and the guttae, which in a stone building otherwise appear so strange suspended below the triglyphs.

This question is, however, of mainly historical importance. More essential to the appreciation of Greek art is the question of why a study of architecture should deal with the orders at all.

Architecture is commonly seen, in many forms, as concerned with the enclosure of space – of 'the emptiness which fills it', to quote the ancient Chinese philosopher Lao-Tse. The true purpose of a building is in many cases to delimit and protect a space. The buildings of the Greeks, however, antedated this concept. Their temples –

▶ The typical Ionic frieze was decorated in its entirety, unlike the Doric equivalent, which was only partly ornamented, by a pattern of metopes and triglyphs. In the Ionic order the frieze completely surrounded the building; and the architrave was divided into three bands, each protruding beyond the one below, unlike the Doric architrave, which was smooth and hewn from a single block of stone.

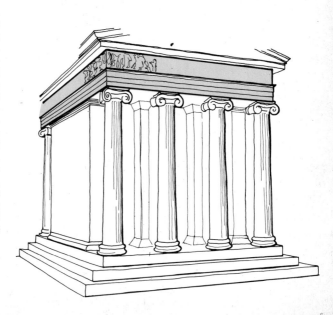

that is to say the architecture most representative of Greek civilization – are impressive specifically because of their external appearance, for the way in which the shell of the building was constructed and embellished. Inside, the cella was in fact nothing more than a badly lit container, a stone strongbox for the image of the god. It was for this purpose that the orders were created – as, among other things, the 'model' of this dress, the device used to guarantee that no building would fall below a minimum quality. Under this system the major concern, the basic form of the temple, had been resolved before any particular plan was contemplated. The individual architect was required only to perfect a theme, not to invent one. If he was a genius, he might create the Parthenon. If not, no harm would be done. His product might be no more than an honest reproduction of what had gone before, but it could never be substandard.

Over the centuries, therefore, by experimenting on precedents, in the form of the 'living room' with its roof supported by columns as in the noble houses of the

▶ The small temple of Athena Nike (to the Romans, Minerva the Victorious) stands on the Acropolis of Athens and is the work of the architect Callicrates. Dating from the end of the fifth century BC, it is a light, elegant structure making use of typically Ionic decorative effects.

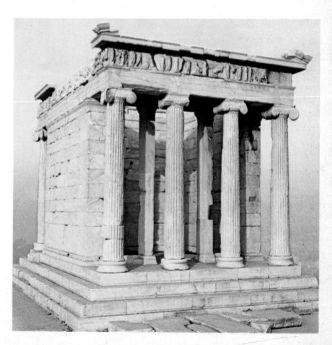

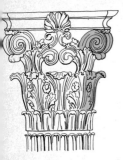

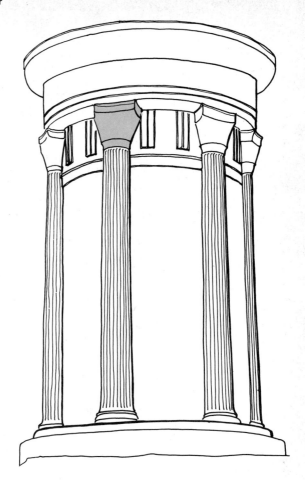

▲ ▶ The Corinthian order was largely a more decorative variety of the Ionic. Its main contributions were a more richly decorated base for the column and a new form for the capital, which was shaped like an upturned bell and decorated with acanthus leaves and four symmetrical scrolls or volutes. It was not often used by the Greeks but was much in vogue among the Romans, especially under the Empire.

Mycenaeans, the colonnaded rooms of the Egyptians, and the early wooden temples, the Greeks established the norm of a certain type of temple built in a particular way. In determining for it one basic shape they developed rules that were too authoritative to be ignored, but flexible enough to leave room for individual achievement.

The evolution of classical Greek architecture took place over a long period of time, from the ninth century BC. Sophisticated architectural forms were achieved by the seventh century; but the highest level of attainment was reached during the fifth century BC, the period of the

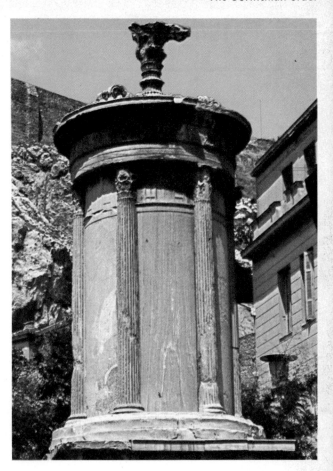

▶ The Choragic Monument of Lysicrates, a little temple erected in 335 – 334 BC, and named after the man who financed its construction. Lysicrates is also known to have paid for the Festival of Dionysus in that year. Here the Corinthian order was used for the first time on the outside of a building, having previously been used only in the form of an isolated ornamental column inside.

great monuments of the Athenian Acropolis. The achievements of these centuries carried such aesthetic conviction and were expressed so powerfully that their system of the orders was subsequently adopted, time and again, by other civilizations. These civilizations made it the basis of their own architecture, but with certain differences. First, their interest was not, as in Greece, centred on the shape of an architectural structure, but on the organization of the space it enclosed. The second difference, which followed directly from the first, was that the orders ceased to determine the structure of the

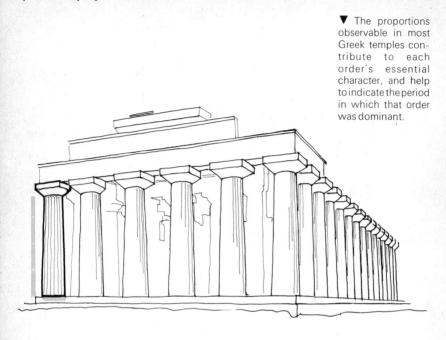

▲ In the Doric the proportions of the columns are less slender than those of the Ionic order; also Doric columns of earlier periods were more massive, and placed closer together, than in later times. The proportions of individual elements were also prescribed. The height of a column always had to be in a given proportion to the diameter of its base.

building and became merely an external 'decoration', something superimposed and inessential. Thirdly, and this follows from the preceding points, the orders ceased to be ideal rules which could be expressed in many different ways, and became fixed examples to be rigidly applied. Invention and design decayed, and dwindled into application of a mere style of ornamentation.

In Greek architecture itself this had never been the case. Here the order and the constructive principle of the building were one and the same. It is the concept, rather than the mere form, that distinguishes a Greek building from others such as a Hellenistic or Roman temple, however similar these might appear. This tendency of structural element to give way to the merely formal began to make itself felt towards the close of the fifth century BC, as Greek art was about to become changed by a different nationality of patronage.

Around this time a third variation was devised. This was the Corinthian style, essentially a version of the Ionic order. The proportions apart, it was in many respects

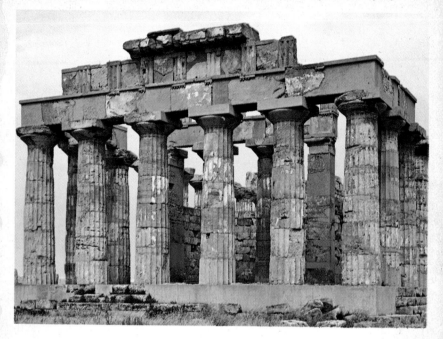

virtually identical to Ionic. The differences lie in the treatment of the base of the column, which in the Corinthian was more elaborate, and, especially, of the capital. Where the volutes of the Ionic order still appear, they do so on all four sides, but now as a minor element. They arise like a plume of large, rather decorative leaves at the top of a very high capital in the shape of an upturned bell surrounded by two rows of acanthus leaves. It is evident that this third order, so much richer than the other two, was invented as a decoration rather than a functional element. Unlike the Romans, who used the Corinthian order to excess, the Greeks in fact used it only for small and rather unimportant structures and even then sparingly.

A little before the development of the Corinthian order, meanwhile, there had appeared a yet more decorative version of the Ionic. This was the caryatid, a unique innovation comprising a column in the form of a statue of a woman. The name commemorates the women of Caria in Asia Minor who, in ancient legend, had been

The caryatid

▼ Caryatids, female statues which take the place of columns in supporting a building, were an outstanding, though little-used, variant of the Ionic order.

enslaved by a Persian satrap.

It was eventually the search for perfection so characteristic of Greek art that undermined the structural use of the orders. As a concept these had been regarded as separable from the structure of the building, so that the building's construction could be seen as an assembly of various elements: base, columns, and so on. But if we analyse examples of the Greek temple at its most developed, for example the Parthenon, we become aware of a whole series of devices additional to merely assembling the elements. The columns are not all equal; some in

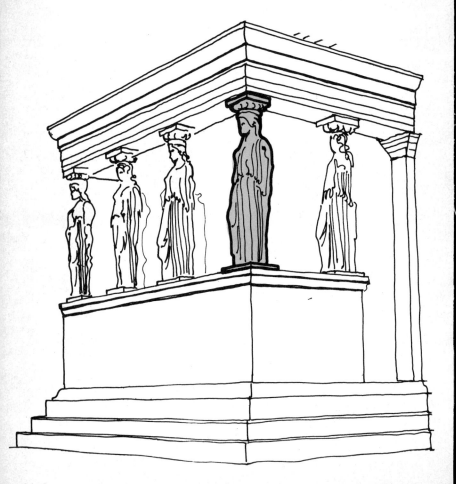

▼ These figures support the roof of the porch flanking the Erechtheum. In this building the frieze is narrower than was generally accepted, and the sculptured decoration and the two sloping roof-lines common to comparable buildings are missing.

the centre of the elevations are a few centimetres higher than those at the corners, so that the horizontal lines are not straight but slightly curved, forming an almost imperceptible central swelling. Again, the columns are not entirely vertical but incline slightly inwards. In other temples of this period the columns along the front elevation are smaller than those at the sides, so that in section the corner column, whose shape combines two circles of different diameters, appears elliptical rather than round. These devices are generally interpreted as optical corrections, a way of inducing the observer by

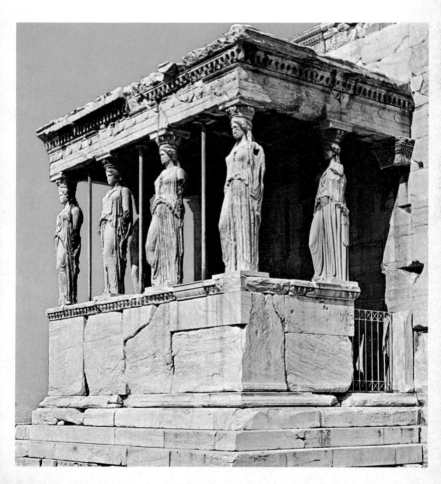

The theatre

▼ The Greeks have often been praised, as builders, for the splendour of their ornamentation, but criticized for lacking a sense of the control of space. This criticism can hardly be applied, however, to their invention of the theatre, one of the most interesting organic structures in the architecture of any civilization.

means of illusion to see the temple as absolutely regular. A long horizontal line resting on a series of verticals does in fact appear curved even when straight. Similarly, a corner column, which is more exposed to the light than the central columns, appears smaller. Such impressions can certainly be effectively counteracted by intentional 'mistakes'.

But these modifications in turn tended to subordinate the parts to the whole; and it was this that endangered the concept of the order. If the art of classical Greece avoided this danger, that of other epochs did not.

Any account of Greek architecture would be incomplete without at least a mention of its second splendid invention, the theatre.

If ever there was a people intent on self-analysis, and on acting it out in public, it was the Hellenes. Their tragedies and comedies were the first and greatest manifestations of their kind, the foundation and supreme achievement of dramatic art. For the performance of these works, a specially adapted location was needed, and

▼ The small arena at Delphi is an excellent example of the Greek theatre. It shows very clearly the relationships between the different parts that commonly made up the whole: the stage surrounded by columns, the semicircular orchestra, and the stepped seating cut into the hillside.

this, in keeping with Greek thinking, was chosen not as an enclosed space but an open hillside. Here a succession of regular steps, the cavea, was hewn, in a semicircle facing a central area known as the orchestra. This central part was intended for the movement and singing of the chorus. It could be round or semicircular in shape but in either case, and all subsequent theatres, it was always adjacent to the third basic element of the Greek theatre, the skene, a simple tent which served the actors as a backcloth. The skene was later transformed into a rectangular space enclosed by columns, and this is the version that has reached us. The theatre was a simple structure, and completely functional. The Romans were later to develop and embellish it by doubling the layout and transforming it into an amphitheatre, and by detaching it entirely from its hillside. They were able to do this because their building techniques permitted the construction of steps entirely supported by masonry, something the Greeks could not do. But the Greek theatre, open to nature and functional in its layout, was

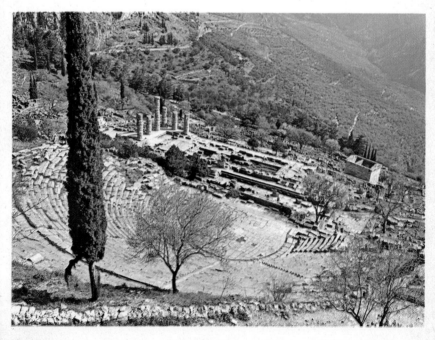

Materials

▶ In their oldest temples the Greeks used wood, and bricks, either sun-dried or baked. These materials were eventually supplanted by stone, which was universally used for buildings of public importance. In Attica and the islands, limestone was used and, above all, marble. Both were hard enough to last for centuries but malleable enough to be worked without too much difficulty. The blocks of stone were joined without mortar. Sometimes, to ensure a perfect fit, their contiguous surfaces were hollowed out so that only the outer edges touched.

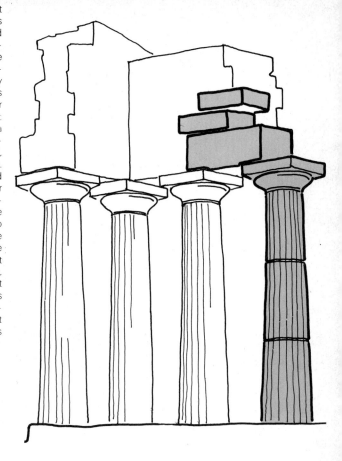

outstanding as an expression of the life of the free city-state, the polis, which was a driving and unifying force of the Hellenic genius. As a monument to the originality of its creators it remains one of the notable innovations of architectural history.

With the transition from the classical period of Greek civilization the architectural styles and forms of the time did not of course undergo any sudden change. Instead, they became in many ways more developed – mainly in their uses, and in the details of individual structures or groups of buildings – while at the same time generally declining from the standards they had formerly known.

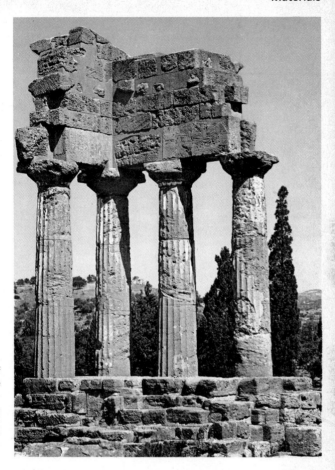

► These partially reconstructed ruins of the temple of the Dioscuri, at Agrigento, give some idea of the sizes and shapes of individual stone blocks generally used.

The orders kept their names and basic forms – although they did undergo some changes of proportion. Generally speaking, in fact, Greek architecture remained for many years recognizable by comparison with what it had been in classical times. After the lapse of three centuries it had changed, however, to the point where it became adapted, and so superseded, by the architecture of the Roman Empire, the first of many civilizations to be inspired by its example.

Sculpture

Surveying the sculptures of the Greeks today is rather like judging the works of Raphael and Picasso from a few faded photographs in black and white. The original works were either plundered, because, like the great ivory and gold statue of Athena which Phidias made for the interior of the Parthenon, their materials were precious, or they were small and fragile. For this reason, unlike the buildings of the time few Greek sculptures of the classical epoch survive. Many are known only through copies which wealthy Romans commissioned for their homes, and when originals are available for comparison, such copies are often seen to be inferior. Some are marble imitations of bronze originals, or the other way round, and in either case the change in material loses the character of the original. Furthermore the originals, though once highly coloured, retain no trace of pigment. Hair and eyes were black, lips were red, and different colours were used for costume. Many early sculptures had been adorned with contrasting tones of red and blue.

In the Roman copies, however, formal qualities are apparent in a way that does render particular original styles recognizable. Luckily, sculpture was a favourite subject of classical authors, and they, too, provide useful information and points of comparison, not least because they differed widely in their views. A rich and extensive body of information is therefore available, not least because, although so much has disappeared, the artistic legacy of Greece far exceeds the entire output of various other cultures.

Many latter-day critics of Greek sculpture distinguish, as with architecture, between the Doric and Ionic styles. In sculpture, however, this was not a distinction made by the Greeks themselves, and in modern times it is disputed

Early Greek sculpture owes its relation to architecture partly to its use on temples, where the friezes and pediments were incidentally intended for the display of sculpture, and also to the fact that both arts had a common background. Both temples and statues were intended to honour the gods, who alone were worthy of such tributes. Greek gods, unlike the deities of ancient Egypt or Persia, were conceived of in man's image, with

▲ ▶ The *Disco-bulos,* or *Discus Thrower,* made by Miron in the fifth century BC, splendidly exemplifies the desire to depict by pre-established rules the human body, to the Greeks the finest thing in creation.

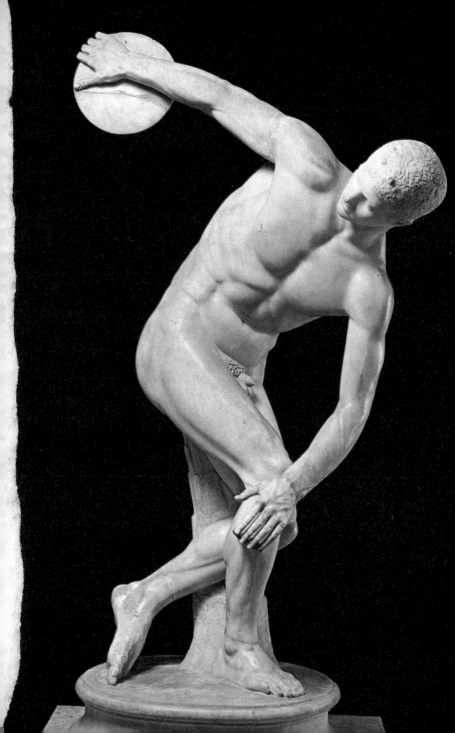

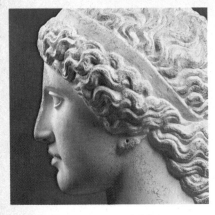

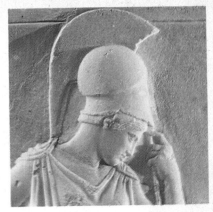

▲▶ In all Greek statues, as on this example attributed to Polyclitus, the line of the forehead is continued virtually to the tip of the nose.

▲▶ The 'Sorrowing Athena', part of a relief of the fifth century BC. This somewhat unrealistic shape of helmet is found only in Greek statues.

human passions and thoughts and, above all, human shapes. One of the famous statements of Greek philosophy, 'Man is the measure of all things', applied equally to the gods.

To the Greeks, therefore, sculpture representing their divinities could only be satisfactory if it was totally human in appearance. Of course, it had to be free of any of the inevitable minor defects found in any actual human being. It had to keep strictly to a 'norm', avoiding anything individual, accidental, or excessive. The shape of any particular man, or, for that matter, of a horse, had to be transcended so that its essential and archetypically human – or equine – character could be revealed.

This was splendid in theory, but marble, bronze, and wood are not easily turned into human shapes. Nor is it easy to represent a perfect being by taking living, imperfect men as models.

In sculpture, therefore, as in architecture, the Greeks took as their starting point a basic norm. They made their subject an idealized figure with a perfect body, and divided human beings, according to age, into categories

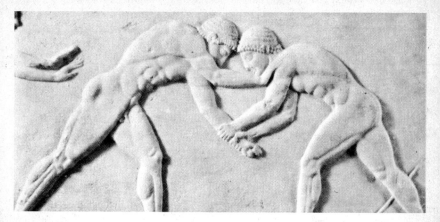

▲▶ A relief depicting athletes fighting, from the Acropolis. Greek sculpture evidences minute attention to detail throughout the human body and to the play of the muscles in particular.

or types, a series of classifications which can be seen in some sense as the equivalent of the architectural orders. There was the boy aged fifteen or sixteen; the young man with the proportions of an adult; the mature man, still full of vigour, bearded and with his muscles hardened by years of training; the graceful young woman; and the grave, sedate mature woman. Children and the aged were excluded as respectively immature and past their prime. The types seen as ideal forms of humanity became the object of efforts to produce examples in sculpture successively nearer perfection.

Classical Greek sculpture is therefore best appreciated in terms of how these typical subjects were handled, including how materials were used in the interest of faithful representation of such types. There is an evident continuity from the rigidity and stylization of archaic sculpture to the precise rendering of the human body in complex attitudes and in minute detail. As this tradition developed, attention came to bear on the particular, on the depiction of individuals; and portraiture, as well as the representation of types, developed.

Luckily for modern observers, in each phase of Greek sculpture except the very oldest, something is known of individual artists. In several cases their names are known and various incidents and anecdotes can be attached to them. Sometimes we also know the systems of rules they followed, and so can describe a particular sculptor's style. Much is known, for example, about the technique of the so-called 'master of Olympia'. We cannot imagine him, however, as a person. But if we know that a sculptor's name was Praxiteles, that he was celebrated for the beauty of his works, and that his mistress was Phryne of Thebes, a famous courtesan of the time, we can hazard an intuition about the workings of his mind and about the models he used. We can perhaps see why he was the first Greek artist to create a nude female statue. This work, the *Aphrodite* of Cnidos, was described by the

► In earlier sculpture, the fear of weakening the stone by cutting into it too deeply was apt to result in a certain stiffness of composition. The arms tended to be held into the body; and in this example the head and the thick neck are merged with the body of the animal. Certain details seem to have been added to the figure rather than cut out of the stone; for instance the protruding eyes, and the thick lips with their typically fixed smile.

Roman historian Pliny as the most beautiful sculpture 'not only of the age of Praxiteles but of any age'. Unfortunately it survived only in a copy.

No such biographical detail is available, however, from the early development of Greek sculpture from the end of the seventh century to the Persian wars, in the early fifth century BC. During this time, while Greek architecture approached a stylistic climax, statuary continued primitive. The reason for this disparity lies in the technical difficulties sculptors found in imposing their will on hard stone. During a century and a half they sought with varying success to produce lifelike shapes from marble, whose limitations had to be transformed into advantages before they could achieve their object.

A typical work of this period, for example the *Moscophoros*, or *Man Carrying a Calf*, commissioned by

▶ The *Moscophoros*, or *Man Carrying a Calf*. It was found on the Acropolis at Athens, and dates from the beginning of the sixth century BC.

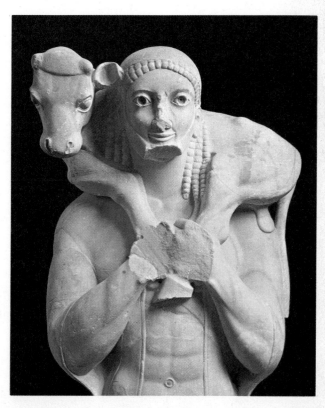

37

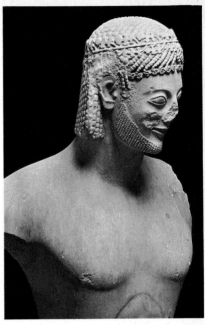

▲ This figure of *c.* 575–550 BC is known as the 'Rampin Horseman', after the man who discovered it in modern times. In the stylization of the hair and beard, the thick lips with their fixed smile, the protruding eyes in their arched sockets and the schematic treatment of the muscles, it displays the special characteristics of archaic art.

the Athenian Rhombos as a votive offering to his patron god, shows clearly how the sculptor was dominated by his material. Very probably he was reluctant to cut too deeply into the stone, since the arms holding the animal, and the man's head, are kept close to the body, making the work look like a low relief of huge dimensions. The head has been shaped in such a way that the eyes, mouth, and nose protrude unnaturally and seem to be added to the stone rather than hewn out of it. The mouth is typical of Greek statuary for a long time to come, in that it wears a fixed ecstatic smile, indicating technical difficulty for the sculptor rather than perfect and unalterable happiness on the part of the subject. The composition is purely frontal and perfectly upright; probably the artist began by reducing the stone to a parallelepiped, then traced the figure on the front of the stone, chipped away all the material beyond the outline, and did the same on the back and sides. This might explain why the work has a squarish effect rather than that of a figure modelled in the round.

Yet the decades of experiment that produced this statue eventually led also to the excellence attained in the

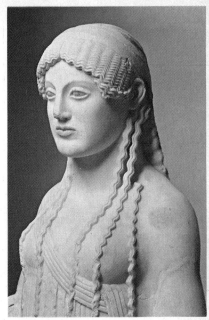

▲ The *kore*, the figure of the young woman, holding out a fruit or an offering, was one of the most typical subjects of archaic Greek art. This statue, which was made about 480 BC, is signed by Euthidicos (not the sculptor but the man who commissioned it as a holy offering), and is one of the archaic style's latest and most perfect examples.

kouros, the young man, or type of figure, used to represent Apollo. This was a nude figure standing stiffly upright, one foot held to indicate a step forward. Although it retains some of the rigidity of the *Moscophorus*, it also marks the transition from a tendency to caricature the human body to one which presents its properties correctly.

Corresponding to the *kouros* is the young female figure, the *kore*. Here the earlier column-like statues with female vestments had been superseded by sophisticated figures such as the *kore* of Euthidicos. The statue of this delightful girl dates from about 480 BC, and is one of the later of over seventy *korai* found by chance on the Acropolis in the last century. It still has some of the archaic characteristics of the *Moscophorus* but in the regular, stylized treatment of the hair and dress it shows an additional technical mastery.

The summit of Greek sculpture was not represented by archaic figures like these; but in characterizing what is known as the 'severe' or 'transitional' style they embodied an undeniable beauty.

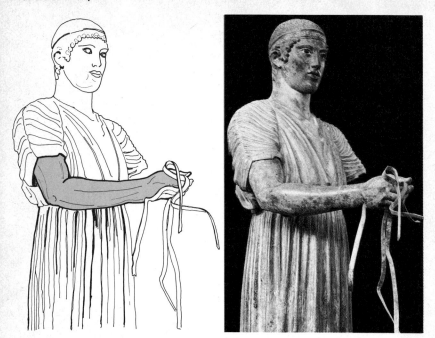

▲ The *Charioteer* of Delphi. This superb sculpture was in bronze in its original form, and part of a quadriga, or four-horse chariot, commissioned by Polizalo, the tyrant of Gela. It is contemporary with the *kore* of Eutidicos shown on the preceding page, and an example of the 'severe' style at its height. Some elements are stylized, but skilfully so, especially the face and the dress.

One of the most representative works of this period is the *Charioteer* of Delphi (see p. 40). This marvellous statue, an original work, was made in bronze in about 475 BC. The expression on the face is almost too calm for a man in the act of imposing his will on four fiery horses; the treatment of his hair and the regular pleats of the tunic below the belt is somewhat stylized, and the statue's general derivation from the rigid *kouros* is still very evident. But an advance towards realism is evident nonetheless: in the sinews of the arms holding the reins, the feet arched to keep their position on the unsteady racing chariot, and the odd curl escaping from the headband.

By the time of the great master Phidias, in the second half of the fifth century BC, the Greek sculptors had achieved complete mastery in the handling of stone, and total control of detail. The tendency to idealize reached its highest expression. All the young men portrayed at this time are tall, slender, and perfectly proportioned, and firm and muscular, without an ounce of excess fat; and the young women are sturdy and full of health. They

▼ ▶ A figure from the group representing the Tyrannicides, or the conspiracy of Harmodius and Aristogeiton against the tyrants Hippias and Hipparchus (514 BC). The Athenians considered them champions of, and martyrs for, the city's freedom. The style is the same as that of the *Charioteer* of Delphi. The original has not survived but there are several differing Roman copies.

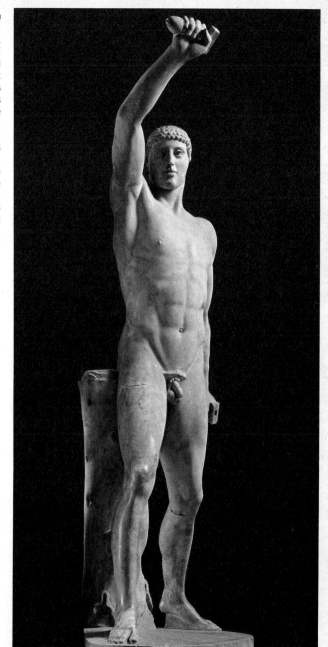

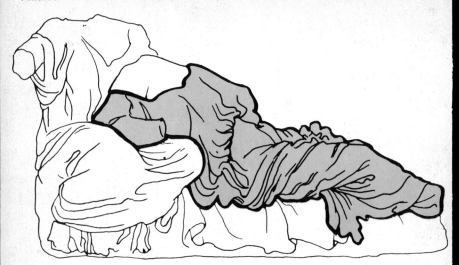

▲ The work of Phidias is on a grand scale, and in a style that breathes serenity. This great sculptor supervised the work on the Acropolis in the lifetime of Pericles, when Athenian power reached its highest point. Artistic expression, in work executed or supervised by him, is no longer dominated by the difficulties of the material. The draperies are ample and very natural, and the sinuous composition is well adapted to its triangular frame.

all display the same Olympian serenity.

In sculpture as in architecture, the Hellenic tendency expressed itself to set up rules first and then to seek the perfect proportions that embodied them; as, for example, according to the rule that a perfect whole is the perfect sum of perfect parts. One of the masters of the epoch, Polyclitus, was particularly highly regarded by his contemporaries, not so much for his achievements as a sculptor as for the system he reinterpreted of arithmetical relationships between the various parts of the body. Polyclitus' canon decreed that the head should be one-seventh of the figure's overall height, the foot should be three times the length of the palm of the hand, the length of the leg from foot to knee should be six times that of the palm of the hand, and the same should apply to the distance between the knee and the centre of the abdomen. To demonstrate these rules he sculpted a statue which has survived in numerous Roman copies, the *Doriphoros*, or *Javelin-Carrier*. This is another *kouros*, representing a naked young man gracefully holding a light javelin. The work appears real, down to the hair and fingernails. The traditional stylized attitude of a marching soldier has been transformed into a carefully calculated rendering of a body about to move. The young man appears delicately balanced, his weight resting on one foot; the

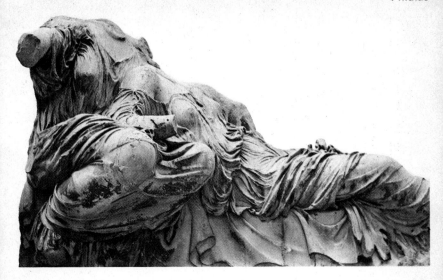

▲ The 'Three God-
desses', of which
the two outer ones
are seen here, once
decorated the pedi-
ment of the Parth-
enon; hence the
pyramidal composi-
tion of the group.
They were made in
the second half of
the fifth century BC.
It is not known
whether these
figures are the work
of Phidias himself or
were made in his
workshop to his de-
sign.

other foot touches the ground with one toe only, ready instantly to take the body's entire weight.

Such work is far removed from the early rigid figures composed along a single vertical axis. Soon the contraposto rhythm depicted by Polyclitus, that of a man shifting his weight from one foot to the other, was to yield to the languid 'S' line favoured by Praxiteles. Greek sculpture had reached the stage of representing the naked body of a man (or, following Praxiteles, a woman) in a natural attitude of graceful relaxation, one arm placed casually on a support, and the other, with a slight upward movement of the shoulder, balancing it while sustaining half the weight of the body. On the side opposite the support, one leg is tensed to bear the remaining weight, while the other leg, which bears no weight at all, only touches the ground with its big toe. The head is slightly inclined, the expression serene and mildly amused.

After two hundred years of continuing refinement the severity of the original Apollo has given way to the languid Hermes (see p. 45), leaning gracefully against a tree trunk, his cloak draped around him, his body carefully posed in an attitude of indolence which shows off his perfect muscles. He is an Olympian exquisite, in whom none of the features of archaic sculpture remains. The stiffness, the stylization of hair, muscles, and

Scopas

▼ Perhaps the least reposeful of classical sculptures were produced by Scopas, whose faces and tortuous lines both expressed tension. This example, from the first half of the fourth century BC, is the *Demeter* of Cnidos, executed either by Scopas himself or a close follower.

draperies, the protruding nose and eyes, and the fixed smile have all disappeared. Everything about him is natural, spontaneous, and perfectly proportioned. The only exception is the infant Dionysus whom the young man is holding so gracefully. He alone is not the perfect realization of a 'type'. He is pretty, lovable, with a chubby body; but he is misshapen. The head is small, the arms and legs long and tapering like those of an adult. When he made this figure the sculptor was thinking of the proportions of an adult. Such a naïve mistake in so refined a work shows very clearly how tenaciously the Greeks sought an ideal beauty, even giving it precedence over the most attractive reality.

The greatest artist of classical Greece is considered to

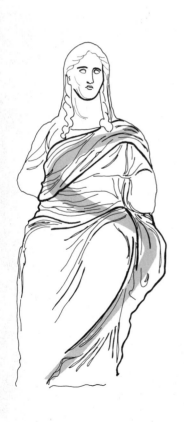

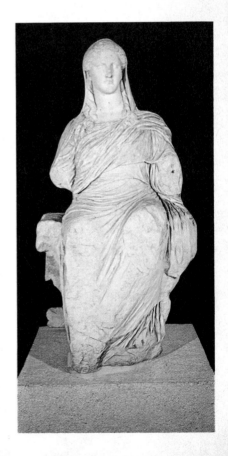

▼ Praxiteles the Athenian was, next to Phidias, the most famous of Greek sculptors, and celebrated for the inimitable languid grace of his figures. Note the faulty proportions of the child in his *Hermes with the young Dionysus*, modelled according to the rules of proportion that governed the depiction of adults.

be Phidias. His work is associated in particular with the Parthenon, the splendid Doric temple erected on the Acropolis by Pericles, the leader of the Athenian democracy. There was no comparable case of a sculptor being closely identified with a building as a whole until Michelangelo provided one two thousand years later.

The entire decoration of the Parthenon – all the sculptures of the pediments, metopes, and friezes – was created by Phidias himself or under his direction. It was an immense undertaking. The internal frieze alone had to cover an area 1 metre high and 160 metres long. Here in particular Phidias demonstrated his extraordinary genius. Not once was a figure repeated, even though the figurative scheme itself was repetitive, representing a

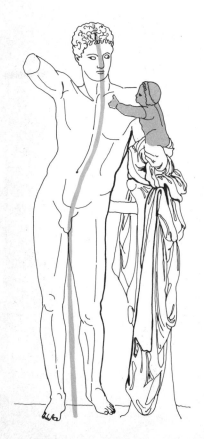

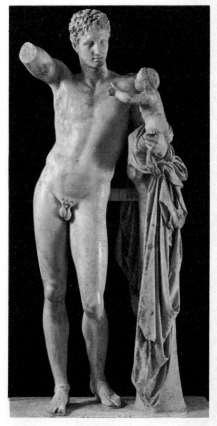

Lysippus

▶ Lysippus was he latest of the great classical sculptors and the favourite artist of Alexander the Great. He was admired for depicting men 'as they appear' and not 'as they are'.

The *Apoxyomenos* is his famous representation of an athlete washing the dust and sweat off his body after the competition. In contrast with the static rhythm of Praxiteles, Lysippus has caught the mood of restlessness in this subject, who is depicted as if still recovering his breath, and balancing nervously on his feet. Lysippus was among the first sculptors to produce actual portraits, the art of portraiture having been largely disregarded in Greece. The most famous portrait by him is that of Alexander the Great.

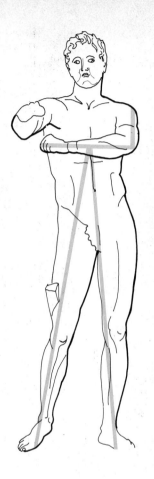

succession of human figures united in purpose and grouped into categories. All are varied in their details and at the same time attain a striking effect of naturalness. The overall impression is that of grandeur and calm, a general quality that is characteristic of Phidias.

This monumentality is particularly impressive in the sculptural groups which decorate the pediments. Here the sculpture had to tell a story, but meanwhile fulfilling the difficult function of fitting within the line of a sloping roof. Phidias, however, was able to turn this difficulty to his advantage. A good example is one of the groups on the eastern pediment, the 'Three Goddesses' (see p. 43).

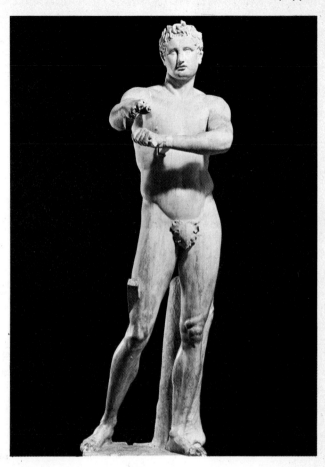

▶ The *Apoxyo-
menos* of Lysippus
has survived only in
Roman copies. This
version is in the
Vatican Museum in
Rome.

Aphrodite, the first, leans serenely against the knees of
the second goddèss, who is perhaps Dione, while the third
is shown in the act of rising from a seated position. The
transition from the outstretched figure to the one rising
is handled so well that it gives the impression of three film
shots of the same person in motion. Here Phidias' style
appears at its most accomplished.

The forms giving the appearance of movement are
beautifully composed, and the serenity of the figures'
attitudes and expressions can still be seen even though all
three heads are missing. Commenting on the divine
tranquillity expressed through these human figures, the

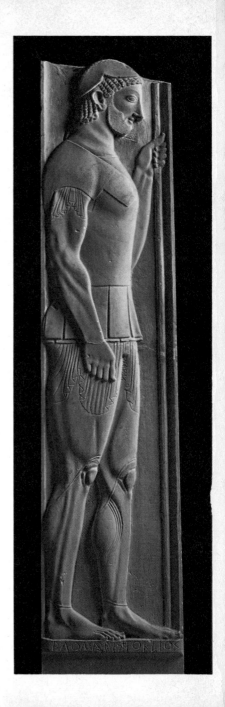

Roman sculptor Quintilian said: 'Phidias has added something to traditional religion, for the nobility of his work is a perfect expression of divine nature.'

A generation after Phidias an interest in human, as opposed to divine, nature began to find expression in the work of Scopas, a native of the island of Paros. Phidias was active during the second half of the fifth century BC, Scopas between 390 and 350 BC. Where Phidias' sculptures appeared serene, Scopas' works register an awareness of anxiety. Their body movements betray a nervous quality; eyebrows and mouths are deeply carved; and draperies are stirred by wind and the movement of the body. In a time of war and of economic and moral crisis following on the loss of political power, the art of Greek civilization was beginning to lose its appearance of Olympian serenity.

Some contemporary sculptures registered no form of motion, however. But the feeling of agitation typical of Scopas was nonetheless pervasive. An example widely attributed to him or one of his followers, is the large figure of the *Demeter* of Cnidos (see p. 44). The disturbed sweep of the 'S'-shaped cloak with its strong chiaroscuro complements the pain in the face of the goddess, anguished at her daughter's abduction.

Lysippus is the last great master of Hellenic art. His subject, too, is the figure of the young man, the *kouros*. In his work this type retained its regularity of feature, but had become restless, about to move or regain breath after making a great effort. Lysippus' *Apoxyomenos* (see p. 47) represents a naked athlete rinsing the sweat and dust of the competition off his body. The contraposto rhythm of Polyclitus and the 'S' line of Praxiteles have given way to a wave-like movement, offset by the outstretched arm but still involving the whole body. And for almost the first time in Greek art the face is preoccupied. It is rightly said of Lysippus that 'where others have depicted men as they are, he depicted what they actually look like'. Representation of the idea of mankind, in other words, was giving way to the portrait of the individual. Indeed, Lysippus is considered by some the first to have made a true Greek portrait – that of Alexander the Great, who, in the name of Greece and her traditions, dug the grave of the liberty of the Hellenes and in the course of imposing their civilization over a

◀ The development of low reliefs followed that of sculpture in the round. This example, a funerary stele, or commemorative one slab, depicts a hoplite, a heavily armed foot soldier. It should be compared with the 'Rampin Horseman' on p. 38, with which stylistically it has much in common. The muscles are not, as yet, closely studied and hair and beard, as well as draperies, are highly stylized.

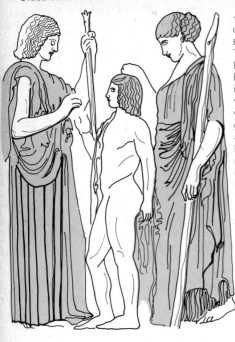

◀ ▶ This low relief of the fifth century BC depicts Demeter, Triptolemos, and Demeter's daughter Persephone. According to the legend the young Triptolemos was abducted by the goddess Demeter and received from her the gift of immortality. The work is considered to be later than that of Phidias. There is a refinement in the gentle grace and serenity of the facial expressions, and the handling of the draperies is very accomplished. The different spacial levels, within the small scope of a low relief, are well brought out and are reminiscent of Phidias.

wide area transformed it.

The same progression, from idealized generalization to portraiture of individuals, took place not only in sculpture made from a block but in the development of low relief from a slab of marble, and follows similar lines. The same technical methods were used, with similar difficulties and successes, and often by the same artists. There also occurred the same transition from rigidity and stylization to a conspicuous naturalness, producing some of the most notable and pleasing works in all of Greek art. The differences between reliefs and sculptures made in the round arose not so much from techniques or fashions as from the function that the individual sculpture was to serve. Most were made as the complement to a piece of architecture rather than as an item in its own right: for example as decoration on the pediments or entablature of a temple. One useful consequence of this for anyone studying Greek sculpture is that such works that survive are more likely to be originals than, say, an isolated figure commissioned by a private individual. They also

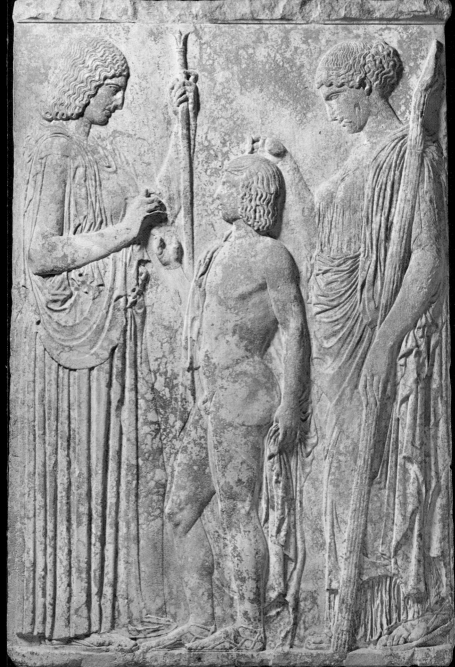

The Parthenon

▼ The low reliefs on the Parthenon were executed under the direction of Phidias; and his hand is evident in the elegance of the draperies and the majesty of the overall composition. Throughout the whole work no two faces or draperies are alike. It is remarkable how Phidias avoided repetition in what, after all, is a group composition.

have a chance of being a great deal less restored, so that however damaged they might be the effect they convey is not likely to be positively misleading. Where they are part of a building, too, they can often be at least approximately dated.

The standard of work on sculptures in relief did vary. At their finest they are exemplified by the fragments of the frieze known as the Elgin Marbles which is one of the most prized of all items to be seen in the British Museum. Other works of the same kind, however, might have been executed by masons of very modest skill. Few were actually by any of the great masters but, more probably, executed under his direction.

Relief sculptures tended to be designed to depict groups rather than a single figure – again as a result of the use for which they were intended. Often they featured an established number of figures, in series of poses of a kind generally found acceptable according to all the stylistic conventions of the time. On a pediment, for example, they might frequently number either three,

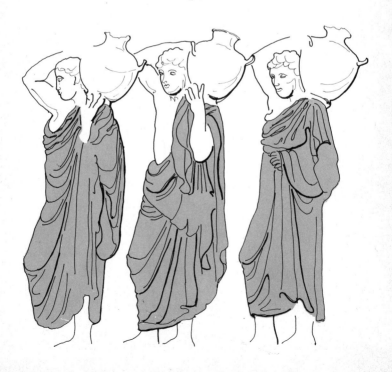

▼ The frieze which borders the walls of the cella of the Parthenon represents a procession in honour of Athena, with figures carrying amphorae. Although part of a Doric temple, its style is typically Ionic.

five, or seven, or a slightly larger odd number; the sculptured figures on some metopes might be grouped in pairs; and on the frieze of many buildings a composition of many different items, even if not totally symmetrical, was apt to be balanced by a slightly more conspicuous central figure. For these reasons, sometimes more than others, one of the most striking characteristics of such sculptures is that they each impress the onlooker simultaneously with their beauty as an individual item, and as a necessary part of a harmonious whole in the form of the temple or other, probably ceremonially oriented, building that they adorn. Like the architecture of the time they were later much imitated, notably, in some of their techniques, by the Romans. But as an expression of the feeling for beauty that inspired them they remain in many ways unsurpassed.

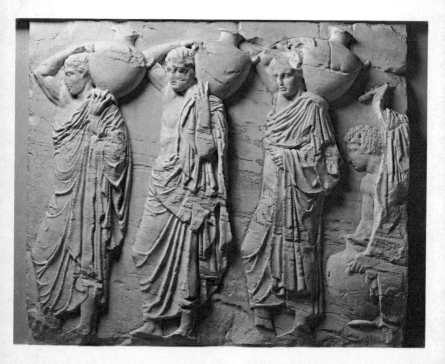

Painting

The Greeks excelled in architecture and sculpture; but they also produced work of the utmost originality in jewellery, pottery, coins, and metalwork of all kinds, including armour. Their craftsmen followed more or less closely the path taken by their architects and sculptors, producing work that showed a similar evolution from severely stylized archaic forms to the marvellous naturalness and technical skill of the later periods. It is difficult, however, to date their work because so much, especially objects made of precious materials, has been lost.

Of Greek painting virtually nothing has survived. One critic has called this 'the gravest loss in the history of art of any period or country'. For observers in ancient times were unanimous in thinking that Greek painting equalled, if it did not actually surpass, the achievements of Greek architecture and sculpture. We can form some idea of Greek painting from occasional fragments and from the painting and design on pottery, which fortunately has survived in large quantities. Greek writers, too, have shed light on the subject. There is, for example, the well-known story of the grapes painted by the artist Zeuxis, whose naturalistic style of painting rendered them so lifelike that birds pecked at them.

It was the fifth century BC that saw the finest work

◀ In comparison with the free composition and the naturalism of Cretan and Mycenaean vases the earliest examples of Greek pottery seem primitive and geometrical. This Greek example of ceramic decoration shows a wasp-waisted man with a triangular torso, driving two stylized horses.

▼ ▶ The amphora was one of the first vessels produced by the Greeks to be standardized both in its ornamentation and its basic form. This example, from the seventh century BC, bears the stylized image of the Mother Goddess, the great earth divinity who was later supplanted by the Olympian gods. Even at this early stage the amphora has the subsequently typical heart-shaped body and cone-shaped neck.

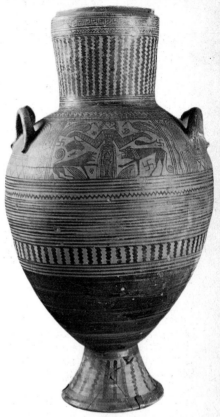

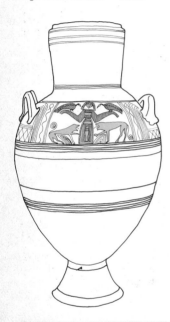

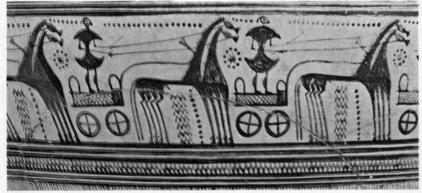

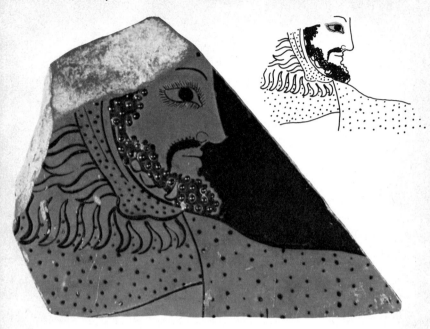

▲ Euphronius, active in the sixth and fifth centuries BC, was a master of Attic vases showing red figures on black grounds in the archaic manner derived from Egypt and Crete. As in all work of this period the eye, painted as if seen from in front, is set into a profile view of the head.

attained in the decoration of Greek ceramics; but the greatest painters of classical Greece are alleged to have lived and worked in the following century. Unfortunately, since so little remains of their work, the evidence of the paintings on surviving pottery only gives us an idea of their drawing techniques rather than their finished work.

Because of the loss of all major paintings, Greek vases provoke interest over and above their intrinsic value, as sources of information about Greek visual art in general. They were not just utilitarian pottery, however, but art objects in their own right. They were highly prized throughout the ancient world, and a major item in Greek foreign trade. They are found in places far removed from Hellenic influence, in distant Gaul and the forests of Germany as well as in the Persian empire. The export of vases was one of the principal means by which Greece, a poor country, could pay for imports of badly needed raw materials.

Greek vases had won their position in the market by their refinement of technique in production and ornamentation. When the Hellenic tribes invaded the Greek

▶ Athens led the Greek world in the production of pottery. Figures on Attic pottery were shown silhouetted in red — the natural colour of clay when baked — on a black ground. This cup, like the work on the opposite page, is from the workshop of Euphronius.

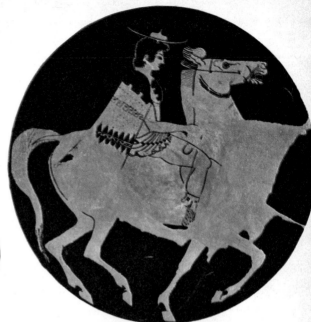

▶ Black figure pottery preceded the style that featured a painted background. Using touches of other colours, it showed black figures on a red ground. This splendid example is known as the Exekius cup after the artist who painted it.

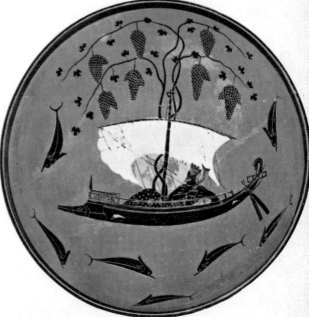

peninsula they found a flourishing pottery production in the great Cretan and Mycenaean tradition. But instead of continuing it they created their own style of pottery, with distinctive shapes and decoration that followed the principles laid down in the Greek major arts. The development of characteristic shapes was gradual. The Greeks were concerned primarily with an object's use, and it was this, not aesthetic reasons, which determined its shape. One of the commonest vessels was the amphora, a heart-shaped vase with a long slender neck and two handles. The hydria (from the same word, meaning water) was a jar for bringing water from the fountain; it had three handles – one vertical, for steadying it while pouring, and the other two for lifting it. The krater, a largish vessel looking like an upturned bell, had a rim shaped like a lip. It was used for mixing wine with water (wine was never drunk unmixed). The oinochoe (from *oinos*, wine) was a jug for wine.

The earliest examples of these vessels date from the eighth and seventh centuries BC. They have a characteristic geometrical decoration (see p. 55), much like that found in the sculpture of the period. The representation of men and animals is extremely stylized. The men have wasp waists and the typical 'axe-blade' profile. Their chariots are shown as rectangles with two small circles underneath, and their horses are no more than a playing with lines. Figures are generally shown in outlines which are completely filled in with colour. These silhouettes are almost always painted in a dark brown on the light brown of the clay from which the vessel was thrown. Sometimes the background of the silhouette is black. This style was shortly superseded by one that was more naturalistic and decorative, and which clearly derived from the then more developed countries of Asia Minor; above all from the important centre of Rhodes.

From the first half of the sixth century BC it was Athens that excelled in the standard of its ceramics as in that of its architecture and sculpture; its products also outnumbered those of all other artistic centres. Athenian vases, universally considered the most beautiful and the most 'modern', were also the most widely exported; and Greek pottery in general became synonymous with 'Attic' ware, the pottery from the region around Athens. These splendid works were decorated with black figures

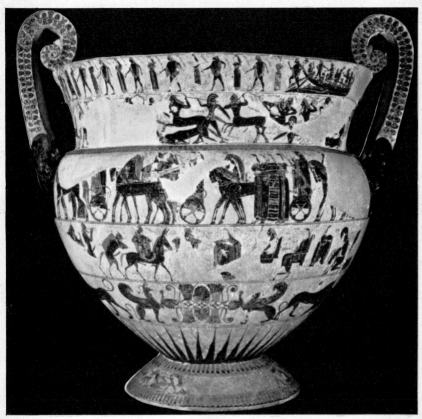

▲▶ The background used in Attic pottery was sometimes light in tone, and gilded instead of red. On this great krater of the sixth century BC, known as the 'François vase' after its discoverer, the use of black figures on a light ground provides a splendid contrast of colours. The 'François vase' was found at Chiusi, in the Etruscan region of central Italy.

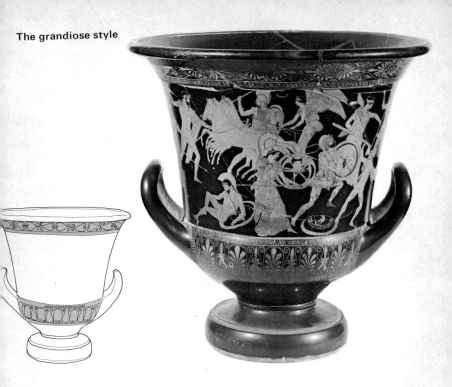

▲ Red figures on a black ground lent themselves more easily to the development of naturalistic images than black figures on a red ground. This example from the first half of the fifth century BC is by the master known as 'the Penthesilea painter'. The borders are in the highly decorative manner known as 'the grandiose style'.

– hence their description as 'black figure vases' – shown in silhouette against the siena-red background of the original material, with no indication of perspective or depth. Archaic forms of representation were still used at this date; for example, the eye was depicted as if seen from in front, while the face was shown in profile (see p. 56).

Towards 500 BC this decorative scheme was reversed. The body of the vase became black and the figures stood out in red. This was not a mere change in graphic style, but an innovation that made possible a radical change. Creating the figures by picking them out of the natural red of the vase meant that they could be enriched with black lines; from now on the silhouettes could be given life by using lines to suggest volume (see p. 60). This development was probably of about the same date as the 'severe' style seen in the *Charioteer* of Delphi or the *Discobulos* – the period, that is, when statues had begun to be modelled with precision but still retained traces of stylization.

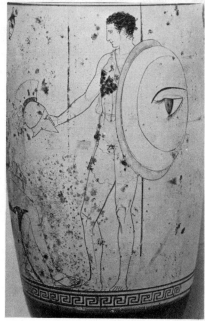

▲ Attic pottery reached its aesthetic culmination in the 'soft style', a typically linear mode of ornament which was, however, useful in suggesting volume and perspective. It is exemplified here on a lekythos — a vase for olive oil or perfume — made in the second half of the fifth century BC.

In pottery, meanwhile, such refinements as the foreshortening of figures were discovered later, together with perspective and the representation of depth in space by means of simple lines giving a three-dimensional effect. This was very different, however, from perspective as understood, for example, by the painters of the Italian Renaissance. On Attic vases perspective meant the stylized device of suggesting receding planes by placing a smaller figure behind a larger one, or indicating distance in space by a few curved lines on the ground. In this way, with these limited means, marvellously realistic drawing was achieved. An example is the lekythos, the container for oil or perfume, shown above.

Over the years Attic pottery slowly came to lose its inventive quality and with it its prestige in the market place. Though the production of black pottery continued, by the close of the fourth century BC Attic pottery had ceased to exist as an art form. At the climax of its aesthetic achievement, however, it equalled the finest work, in whatever form, of any master of Greek art.

Glossary

Abacus: on a Doric column, a square of stone surmounting the echinus and supporting the architrave; on an Ionic column, a stone slab separating capital and architrave.

Architrave: the stone element which joins two pilasters or columns. It is the lowest part of the entablature.

Canon: in sculpture, those definitions of the relationships between different parts, and of the parts with the whole, which are considered indispensible for a harmonious effect.

Capital: the upper part of the column which supports the architrave. In the Doric order the capital has a separate abacus and echinus, in the Ionic it has separate volutes, and in the Corinthian separate acanthus leaves.

Caryatid: a column shaped like a woman, and so called in memory of the slavery endured by the women of Caria in Asia Minor.

Cavea: in the Greek theatre, the semicircle of steps reserved for spectators.

Cella: the innermost room of a Greek temple, where the image of the god was kept.

Corinthian: the third of the Greek architectural orders. Distinguished above all for its capitals, richly decorated with leaves of acanthus, a wild thistle.

Cornice: the uppermost horizontal of the entablature.

Doric: the first of the Greek architectural orders, characterized by fluted columns without bases, capitals with an abacus and echinus, and friezes with triglyphs and metopes.

Echinus: the curved element which in a Doric capital separates the shaft from the abacus. Its curvature varies according to period. It is very pronounced in the archaic period, hardly at all in later forms.

Entablature: horizontal elements in a Greek temple, consisting of architrave, frieze, and cornice.

Fascia: in Ionic, each of the three projecting horizontals making up an entablature.

Frieze: the element in the entablature between the architrave and cornice. In the Doric order it consists of metopes and triglyphs; in the Ionic and Corinthian orders it takes the form of a continuous band, sometimes carved.

Guttae: in the Doric order the cylindrical or cone-shaped pegs under the triglyphs.

Ionic: a Greek architectural order, characterized by columns with bases, capitals with volutes, fluted shafts with fillets between fluting, and friezes which are sometimes carved.

Krater: a large vessel with a wide mouth and handles, used to mix wine and water, or as a principal container from which to replenish smaller containers during a meal.

Metope: a square or rectangular surface, often decorated with sculpture, forming part of a Doric frieze.

Mutule: an element ornamented with pegs which projects from below the cornice of a Doric temple.

Order: in classical Greek architecture, the combination of column and entablature according to one of the established modes; in particular the Doric, Ionic, and Corinthian.

Pediment: a triangular architectural element in which the front and rear elevations of a Greek temple culminate, covered by a roof with sloping sides.

Plinth: an element of the base of the column, found in the Ionic and Corinthian orders but exceptional in the Doric.

Skene: that architectural structure in a theatre forming a backdrop before which the actors perform. It consists of the stage and a series of elements representing the supposed scene of action.

Stele: a slab of stone, sculpted or incised, erected on a sacred memorial place, generally a tomb.

Stereobate: masonry supporting columns or a wall.

Stylobate: the top step of the stereobate, on which the columns rest.

Triglyph: a stone slab with vertical flutings — from 'glyph', a triangular-shaped groove. It decorates the frieze in the Doric order, alternating with the metopes.

Volute: a scrolled decoration on the capitals of orders, including Ionic and Corinthian.

Bibliography

Adam, S., *The Techniques of Greek Sculpture in the Archaic and Classical Periods,* Thames and Hudson, 1966.

Arias, P., and Hirmer, M., *A History of Greek Vase Painting,* Thames and Hudson, 1962. A collection of illustrations with an introductory essay.

Berve, H., and Hirmer, M., *Greek Temples, Theatres and Shrines,* Thames and Hudson, 1963. A good introductory essay on how Greek sanctuaries functioned; well illustrated.

Lawrence, A. W., *Greek Architecture,* Penguin Books, third edition, 1973. A systematic account of the development of Greek architecture.

Lullies, R., and Hirmer, M., *Greek Sculpture,* Thames and Hudson, second edition, 1960. An introductory essay together with a good collection of reproductions.

Richter, G.M.A., *A Handbook of Greek Art,* Phaidon, 1959. A good introduction.

Richter, G.M.A., *The Sculpture and Sculptors of the Greeks,* Yale, 1950. A standard work.

Robertson, M., *A History of Greek Art,* Cambridge University Press, 1975. A masterly summary of Greek figure art.

Sources

Acropolis Museum, Athens: 34 (right), 37, 39, 53; Archaeological Museum, Ferrara: 60; Archaeological Museum, Florence: 59; Archaeological Museum, Milan: 56; British Museum, London: 43, 44; Delphi Museum: 40; Louvre, Paris: 38; National Archaeological Museum, Naples: 41; National Museum, Athens: 5, 34 (left), 35, 49, 54, 55, 61; National Museum of Roman Art, Rome: 32; Olympia Museum: 45; Staatliche Antikensaminlungen, Munich: 57 (top and bottom); Vatican Museum, Rome: 47; Villa Giulia, Rome: 4 (below)

Index

Numbers in italics indicate illustrations.

Index

Photocredits

Alpago-Novello: 14, 23, 27; Pedone: 15; Pucciarelli: 13; Ricatto: 10; Ricciarini-Tomsich: 7; Rizzoli: 4, 5, 17, 19, 21, 25, 29, 31, 33, 34, 35, 37, 38, 39, 40, 41, 43, 44, 45, 48, 51, 53, 55, 56, 57, 59, 60, 61; Scala: 47; S.E.F.: 9